HOW TO DRAW
HORSES

Marty Noble

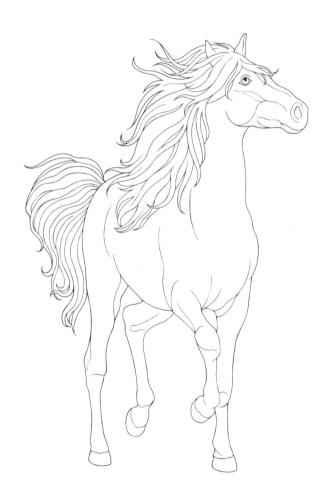

Dover Publications, Inc.
Mineola, New York

Bibliographical Note

How to Draw Horses is a new work, first published by
Dover Publications, Inc., in 2016.

International Standard Book Number

ISBN-13: 978-0-486-80681-5
ISBN-10: 0-486-80681-2

Manufactured in the United States by RR Donnelley
80681201 2016
www.doverpublications.com

HOW TO USE THIS BOOK

This book provides you with step-by-step instructions for drawing your own beautiful horses. There is also a completed, black-and-white, full-page line drawing of each horse for you to use to experiment with different media and color techniques. When you are ready to begin drawing your own horses, turn to the back of the book, where you will find bordered practice pages. The practice pages are perforated for easy removal and display.

Horses are a popular subject among professional and amateur artists alike, and have been a favorite theme throughout history. Here are some useful facts to keep in mind when drawing horses:

- The front of the hoof is longer than the back and is really a big toe. In essence, the horse travels on its tip toes.
- The horse's tail has a bone in it which influences how it can move and hold a position.
- The position of the ears, which can rotate in any direction, may reveal the horse's mood and frame of mind.
- The horse has the largest eye of all land mammals.
- Horses use their ears, eyes, and nostrils to express their mood. They also communicate their feelings through facial expressions.

It is helpful to have some understanding of horse anatomy before starting to draw. Take some time to study the full-page drawing of the horse you want to draw. Notice the basic shapes and muscle groups that make up the horse's body. The legs of the horse are thick and muscular at the top but get narrower as they taper down to the hooves. Horses have several gaits—stand, walk, trot, canter, and gallop—all of which influence the leg position. The first lines you will make are guidelines which will be erased in your final drawing. They serve as the foundation on which you will build your drawing.

Lightly draw in the larger areas of the horse's body as shown in the first step. Note that light blue lines in each step indicate the new elements you will be adding to your drawing. Keep your pencil lines on the light side as you develop your drawing so that erasing is easy. After the final step, you can shade your drawing with pencil graphite, or color it in with colored pencil, watercolors, or another media of your choice. Experiment with soft and hard pencils to find what suits your taste.

AMERICAN PAINT HORSE

1. Draw an oval outline; note that the rump is higher. Extend the line of the right side of the oval to create the neck. Draw a smaller oval for the head. Outline the tail, mane, and the front and back legs.

2. Add some wavy lines to the tail and mane. Add the ears, and refine the shape of the head and jaw. Add detail to the front and back legs.

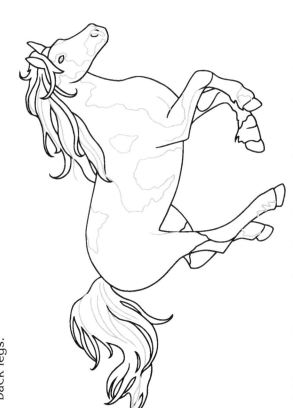

3. Add more lines to the mane and tail. Add a nostril and the outline of the eye. Refine the shape of the legs and add hooves.

4. Add more lines to the tail and mane. Add detail to the lower legs. Outline the areas on the body to represent the dark and light patches of the coat. Enhance your drawing with additional detail as shown on the next page.

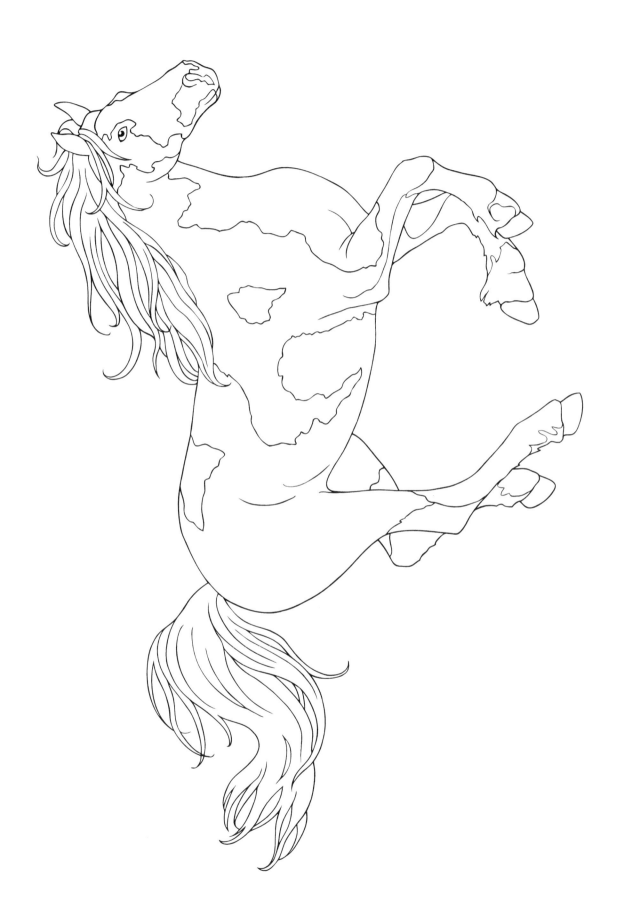

AMERICAN QUARTER HORSE

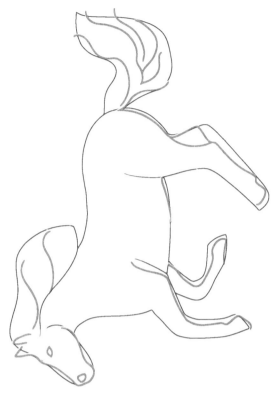

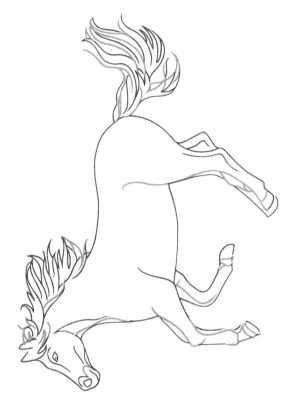

1. Draw a continuous outline for the horse's body. The buttocks should be round, and the back legs should be drawn at an angle. Draw the neck and outline the head, mane, and front legs. At this stage the front legs will appear shorter than the back legs.

2. Add lines to the mane and tail. Add the ears, outline the eye, and refine the shape of the head. Define the back of the legs and hooves.

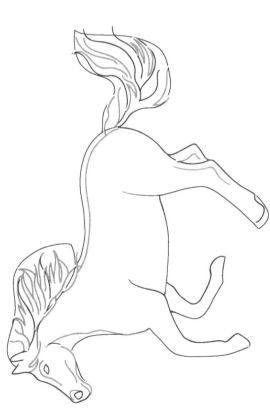

3. Add more line work around the nostril, mouth, and face. Define the back, and add more lines to the mane and tail. Add angled lines to the back legs in the area where they bend.

4. Refine the legs, neck, mane, and tail. Enhance your drawing with additional detail as shown on the next page.

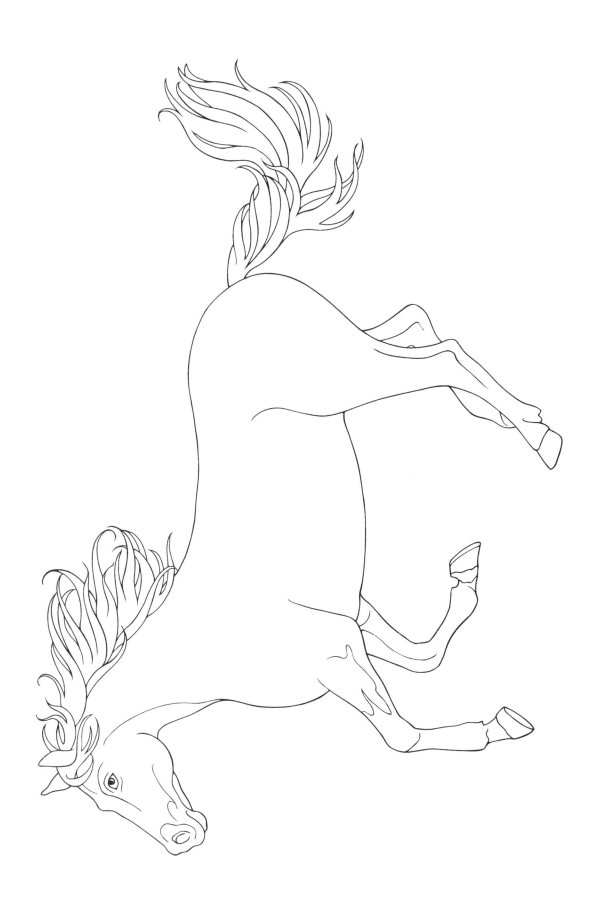

AMERICAN SADDLEBRED HORSE

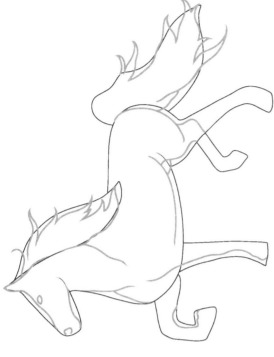

1. Before you begin, notice the upright position of the horse. Draw the outline of the body, neck, head, mane, and tail. Add the front legs and the back legs. Be sure that each leg is positioned at a different angle.

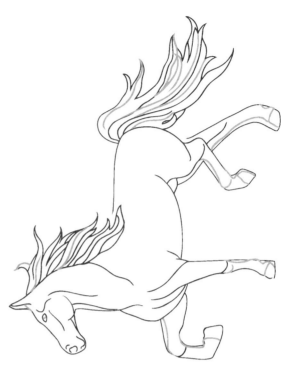

2. Define the mane and tail. Add the outline of the eye and nostril, and add lines to the head to enhance its shape. Refine the neck, belly, and legs.

3. Add more detail to the horse's head, mane, and tail. Add lines to the chest and legs to show the horse's musculature.

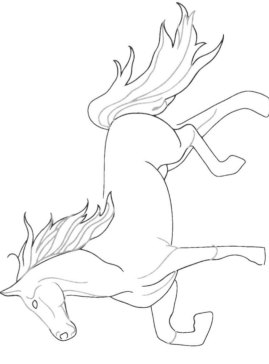

4. Add a few more lines to the mane and tail. Refine the legs, and add lines to indicate the hooves. Enhance your drawing with additional detail as shown on the next page.

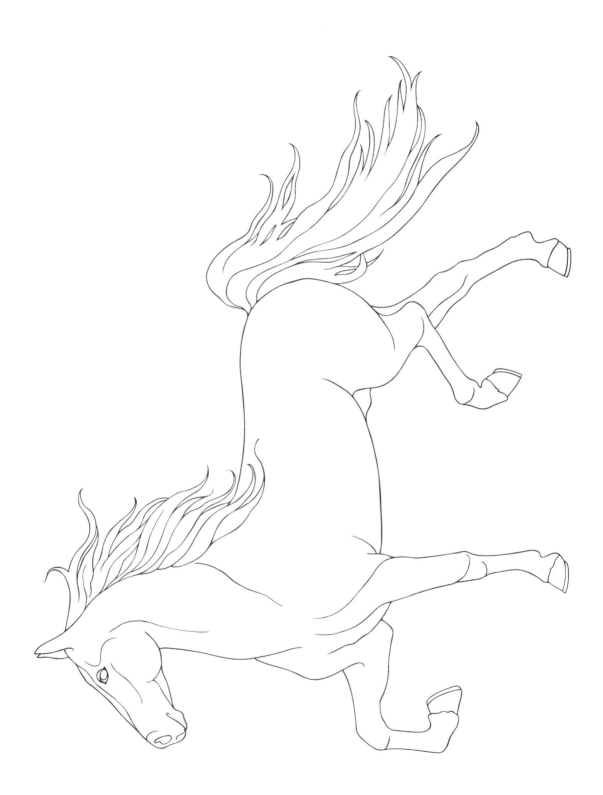

AMERICAN STANDARDBRED HORSE

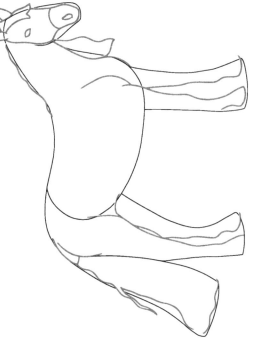

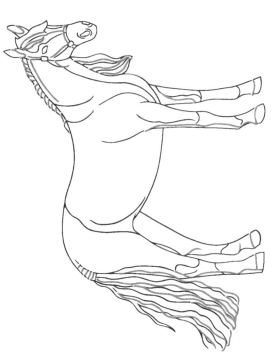

1. Draw an oval outline for the body, extending the right side in order to form the neck and head. Add the rump and extend it down to create the hind legs. Outline the front legs and the tail.

2. Draw wavy lines for the mane. Add ears, an eye, and a nostril. Refine the legs and add a curve for the front shoulder.

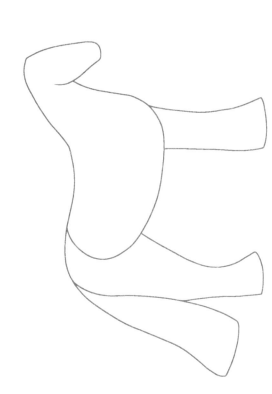

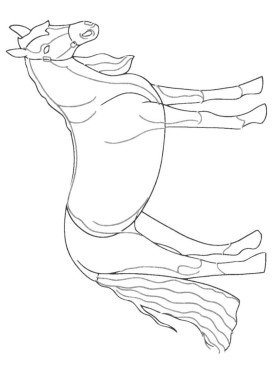

3. Add wavy lines to the tail. Add detail to the joints of the legs. Add curvy lines on the horse's body for muscle definition. Add detail to the head indicating a bridle.

4. Add detail to the top of the mane and the tail. Finish the bridle, and draw more lines in the legs to define their shape. Enhance your drawing with additional detail as shown on the next page.

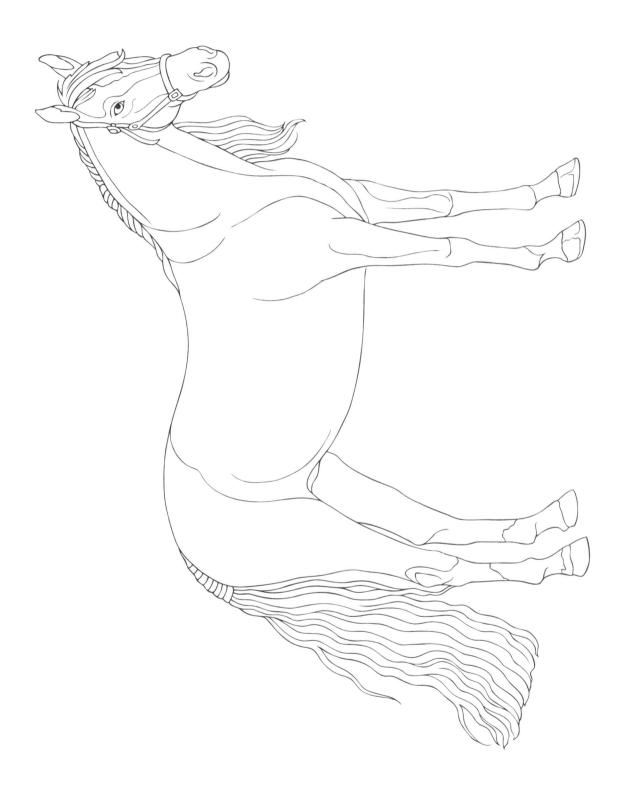

APPALOOSA

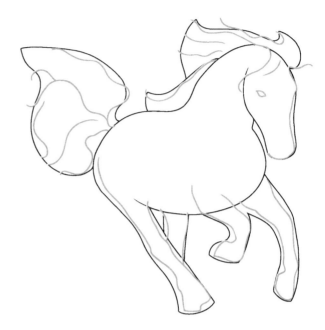

1. Draw an oval for the horse's body, bringing your lines up to form the head and neck. Because of the angle of the horse, the chest will appear very rounded. Add shapes for the mane, legs, and tail.

2. Add detail to the mane and tail. Draw the outline of the eye, and refine the shape of the head. Refine the horse's legs; take care to notice the angles of the hooves.

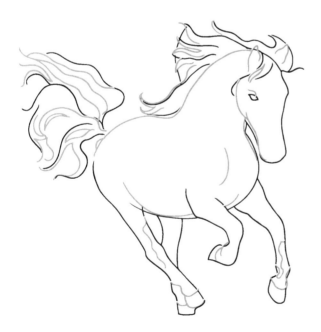

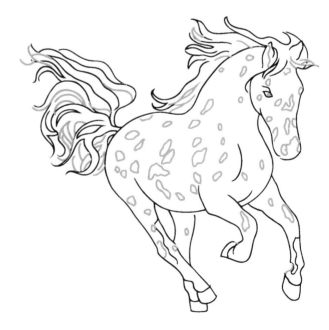

3. Add line work to the head and neck, and add more detail to the mane and tail. Add some lines to the horse's body to suggest muscle definition.

4. Add more lines to the mane and tail, and outline the spots on the coat. Enhance your drawing with additional detail as shown on the next page.

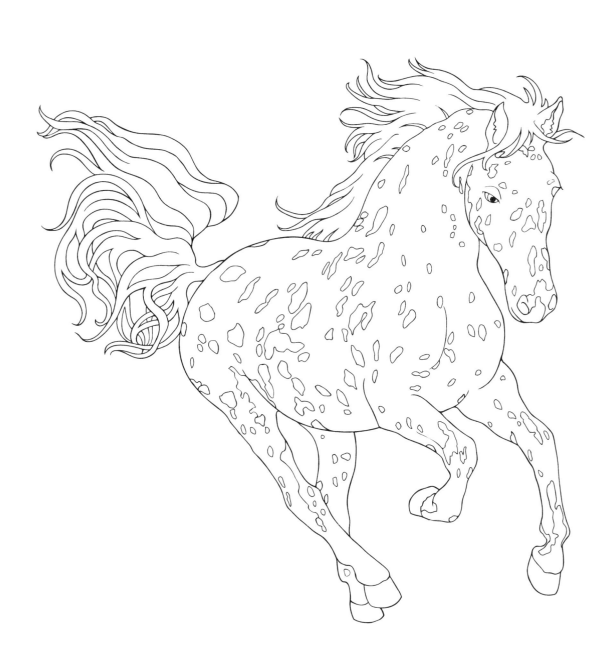

ARABIAN

1. Draw the outline of the horse's mane, leaving plenty of room for the upright body. Add the shape of the head, and an angled oval shape for the body. Add a shape for the tail, intersecting it with a wavy line. Outline the back and front legs.

2. Refine the outline of the body to create a more life-like shape. Add detail to the legs, and take care when drawing in the area where they meet the body.

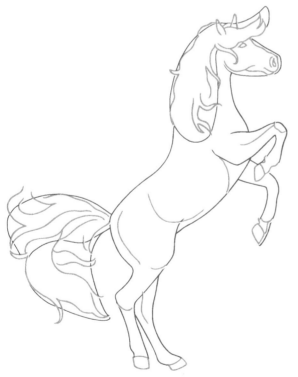

3. Add more lines in the body and the legs to suggest muscle definition. Draw in the eye and nostril, and add wavy lines to the mane and tail.

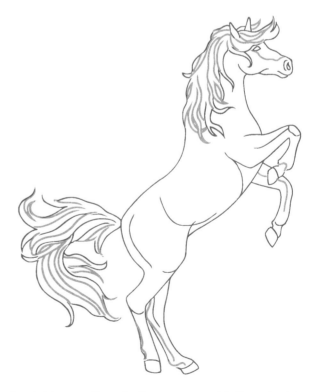

4. Add more lines to the mane and tail, and add more definition to the legs and the head. Enhance your drawing with additional detail as shown on the next page.

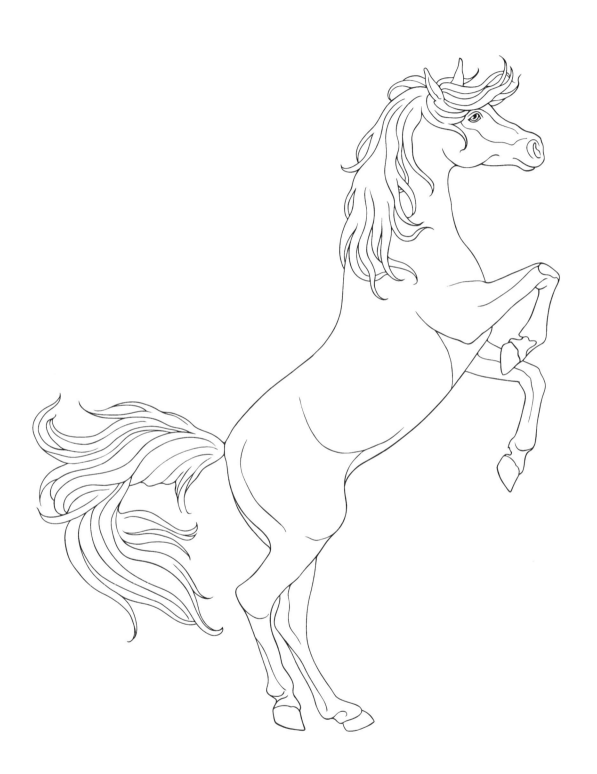

CLYDESDALE

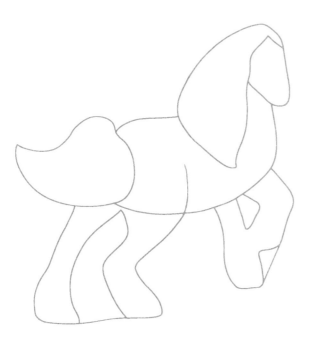

1. Draw large, curved shapes for the mane and tail, and an oval shape for the body. Draw a small, triangular head, and outline the legs.

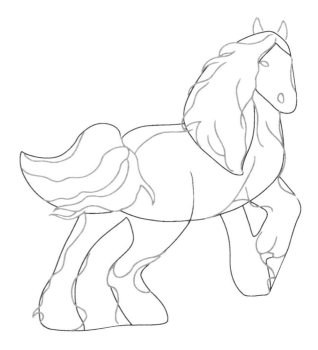

2. Add wavy lines to the mane and tail, and define the horse's back. Add the ears, an eye, and a nostril. Refine the shape of the head. Begin to add some detail to horse's legs, taking care to emphasize the feathery area near its ankles.

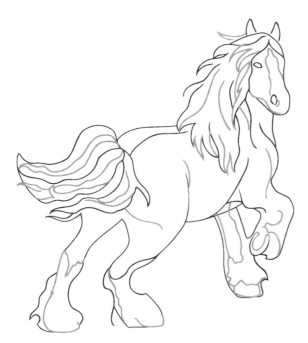

3. Add more lines to the mane and tail, detail the nostril, and add a blaze to the face. Add lines to the body indicating the Clydesdale's stocky build.

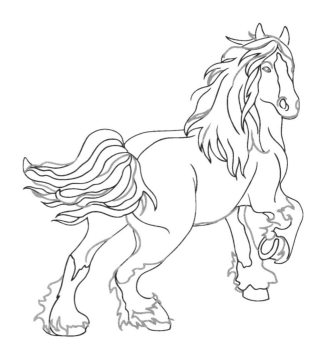

4. Define the distinctive, feathery area on the lower legs, and add more detail to the face, mane, and tail. Enhance your drawing with additional detail as shown on the next page.

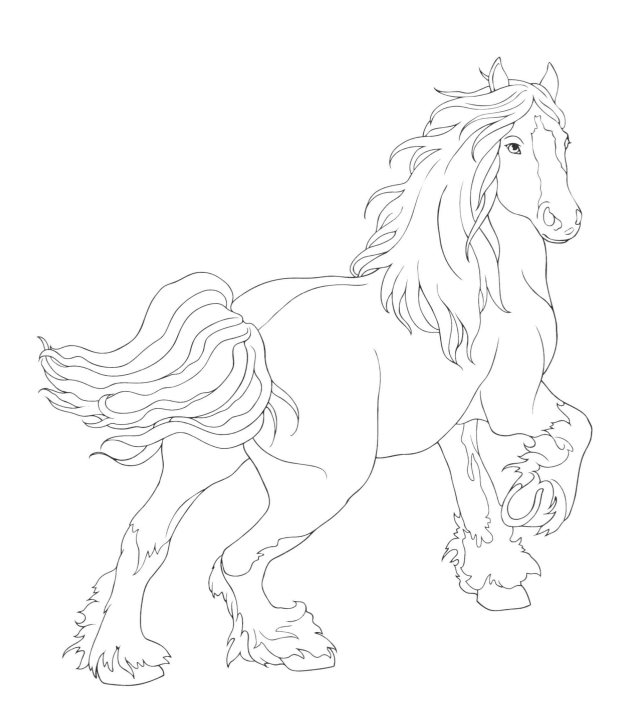

FRIESIAN

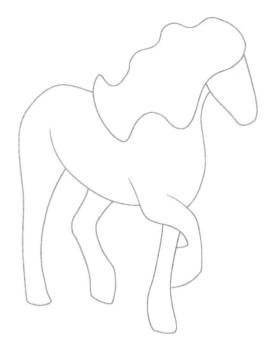

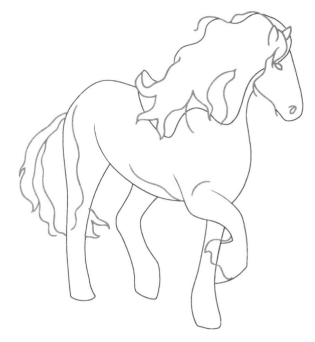

1. Draw an irregular, wavy shape for the mane and out-line the head. The line of the neck should be drawn very close to the mane; it will create a slight S shape as it continues into the chest. Add a tilted oval shape for the body, and draw the outline of the legs.

2. Add wavy lines to the mane and tail. Add the ears, and outline the eye and nostril. Define the jaw area. Add some detail to the feathery area near the horse's ankles.

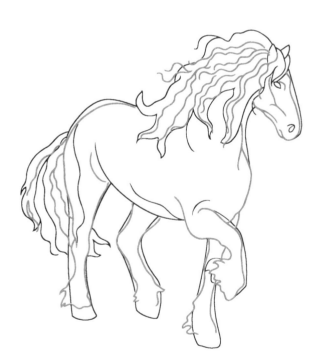

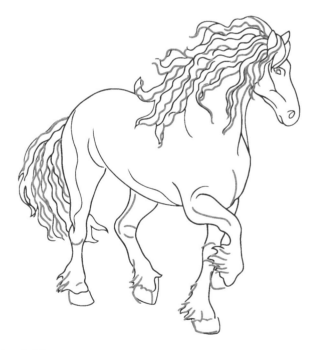

3. Refine the head and face, and add more lines to the mane and tail. Add some lines to the body and legs for muscle definition.

4. Add more wavy lines to the mane and tail, and add accent lines to the chest and upper legs. Enhance your drawing with additional detail as shown on the next page.

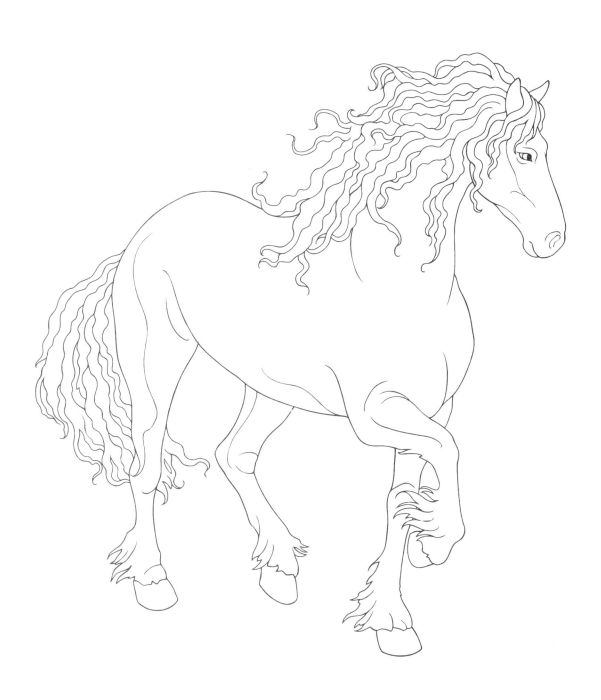

MISSOURI FOX TROTTER

1. Draw a basic outline for the mare and the foal. The mare is running at a slight angle, while the foal is tilted a bit to the right. Add shapes for the mane and tail of the mare. Add a small oval for the foal's tail.

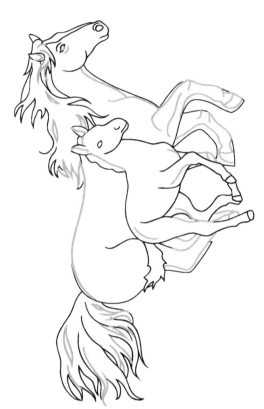

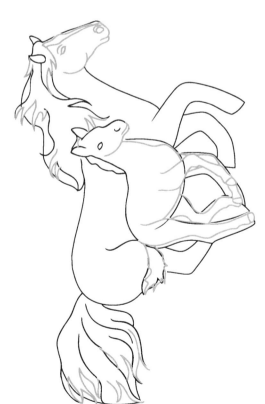

2. Add defining lines to the manes and tails. Add ears and eyes, and add detail to the shape of the heads. Draw a line to show the shape of the mare's back leg, and add definition to the foal's back and neck.

3. Refine the mare's head by adding more lines to the mane, and outlines of the eye, nostril, and blaze. Refine the foal's legs, tail, and chest. Draw more lines in the mare's tail.

4. Add definition to the mare's legs and hooves, and detail the foal's legs, neck, and ears. Enhance your drawing with additional detail as shown on the next page.

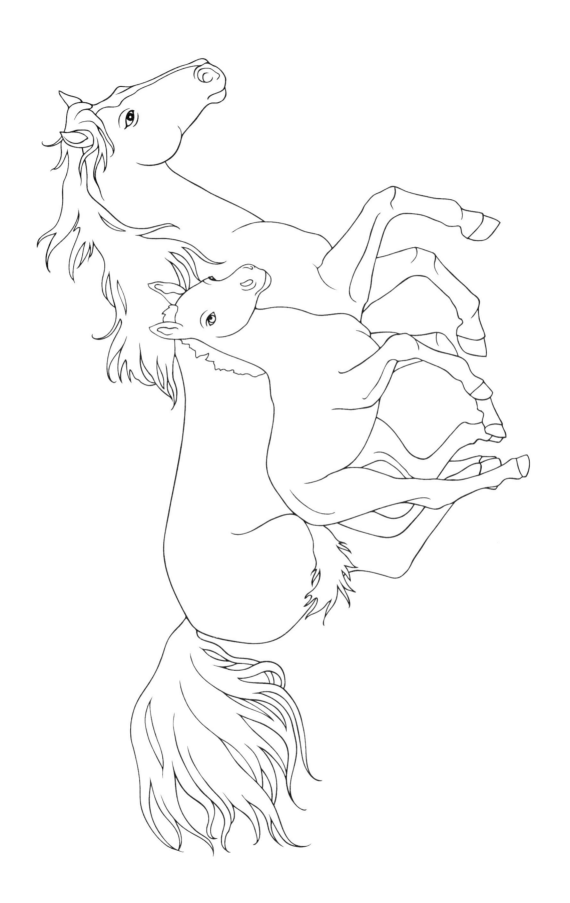

MORGAN PALOMINO

1. Draw a rounded outline for the body. Draw the neck and the shape of the head, overlapping the body and connecting the two. Outline the tail. Add the legs, taking care to note how they taper in a somewhat triangular shape towards the hooves.

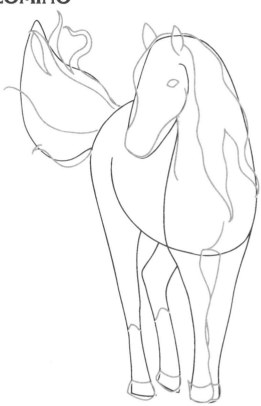

2. Add some wavy lines to the mane and tail. Add the ears and an outline for the eye. Refine the shape of the head, neck, and the front legs. Define the hooves.

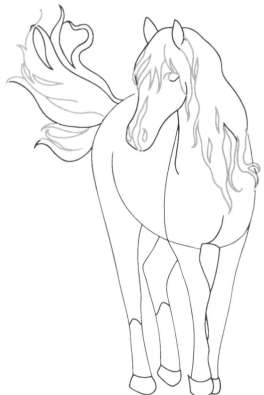

3. Add more lines to the mane and tail, add the nostrils and a blaze on the face.

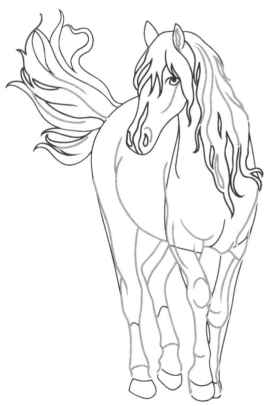

4. Add more definition to the mane and tail, and refine the face. Detail the legs, taking particular care around the knees. Enhance your drawing with additional detail as shown on the next page.

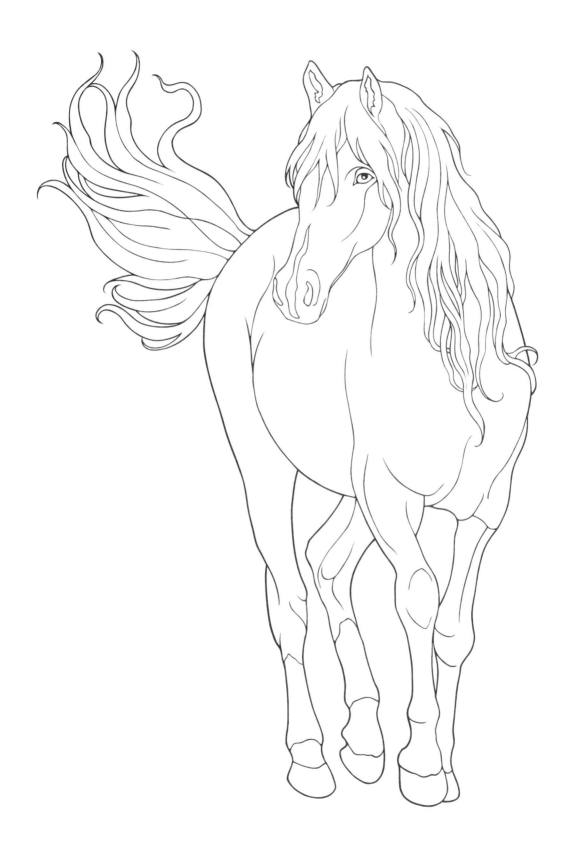

MUSTANG

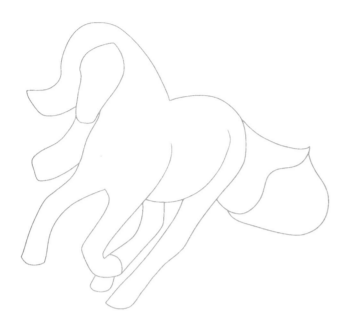

1. Draw a tilted oval shape for the head, and add a shape around the head for the mane. The back of the mane meets the body at approximately the halfway point. Continue the body, noting the angle of the legs. Draw the shape of the tail with a wavy line crossing through it.

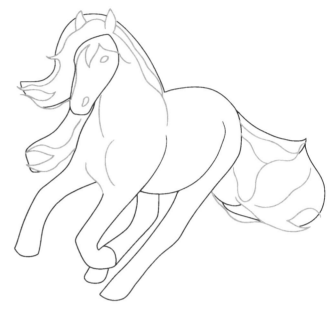

2. Define the mane and tail. Add the ears and an outline for the eye. Add wavy lines on the forehead to represent the front of the mane. Add a few lines to the neck and shoulder area.

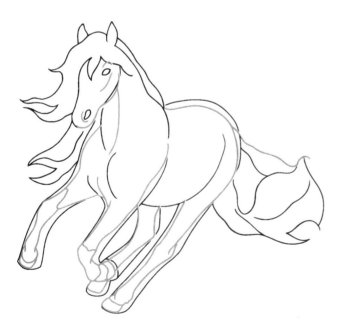

3. Draw more lines on the body and legs, accentuating the curves and angles of each area. Pay particular attention when defining the parts of the legs that meet the hooves. Add some accent lines to the face.

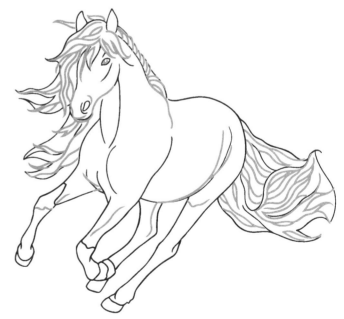

4. Continue to define the legs and belly, and add definition around the mouth. Add wavy lines through the mane and tail. Enhance your drawing with additional detail as shown on the next page.

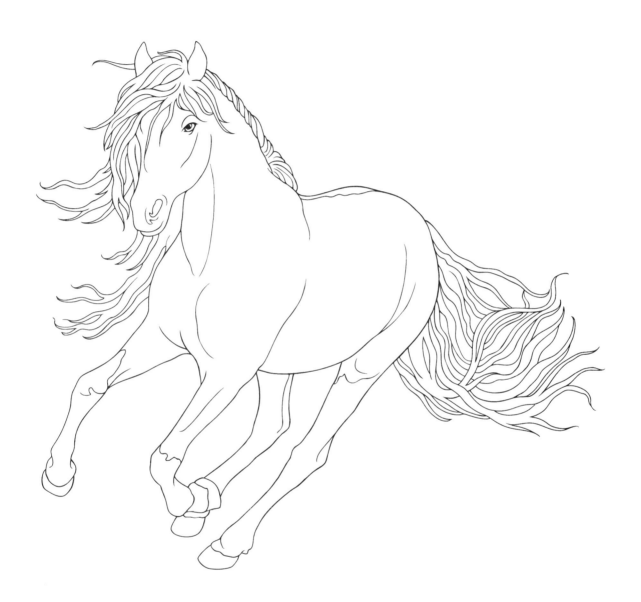

PASO FINO

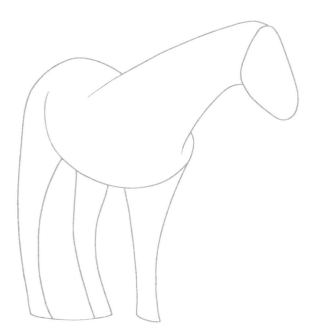

1. Draw a tilted oval shape for the body with lines for the neck extending upwards and to the right. Add a smaller oval shape for the head. Notice how the neck intersects with the body and appears to be quite long. Add shapes for the front and back legs, taking note that the tail will be included in the shape you drew for the back legs.

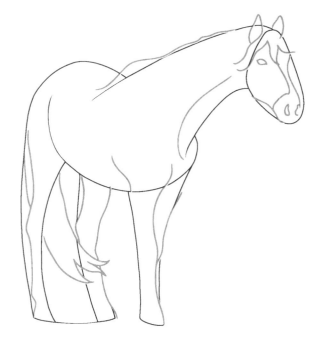

2. Add lines to indicate the tail coming through the back legs. Add the ears, nostrils, an outline for the eye, and additional lines on the head and neck. Add some detail to the shape of the legs.

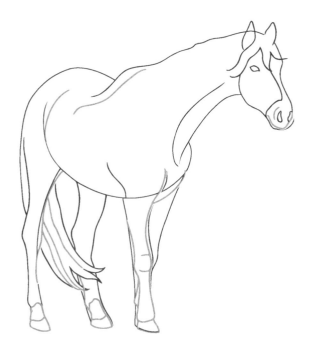

3. Add lines around the mouth, and add some definition to the body. Refine the legs and hooves, and add wavy lines to the tail.

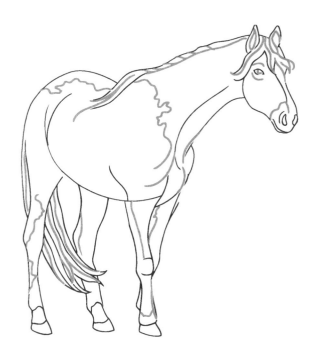

4. Add more lines to the tail and define the mane with small strokes on the ridge of the neck and between the ears. Draw some accent lines down the back and on the shoulder area. Enhance your drawing with additional detail as shown on the next page.

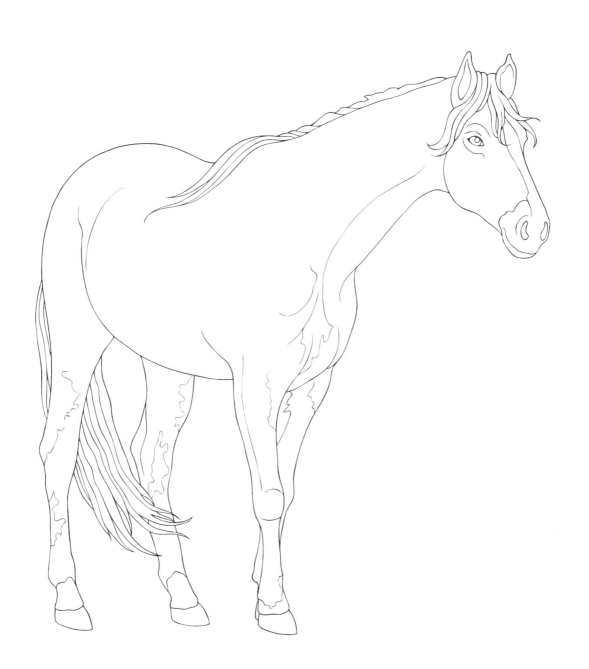

ROCKY MOUNTAIN HORSE

1. Outline the horse's mane, noting that it will cover a large portion of the horse's body. Add the head, and then draw a line down from the jaw area to the front hoof. Finish the line with a shape for the front legs. Add a line for the belly, and add a shape for the horse's rump and back legs. Draw a shape for the tail.

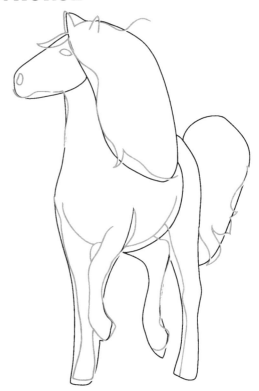

2. Define the shape of the mane and the tail. Add the ears, and shapes for the eye and nostril. Add line work to the head and neck. Define the front and back legs. Add intersecting lines on the chest and belly, connecting them to the legs.

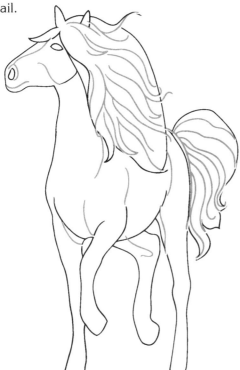

3. Refine the horse's head with more lines, and add a blaze on the face. Add wavy lines to the mane and tail, and more definition to the body and legs.

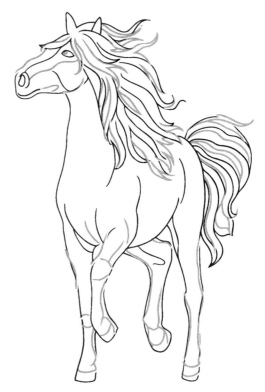

4. Add more lines to the mane and tail, and definition to the face. Add detail to the legs and hooves, noting the angles and the various ways the legs bend. Enhance your drawing with additional detail as shown on the next page.

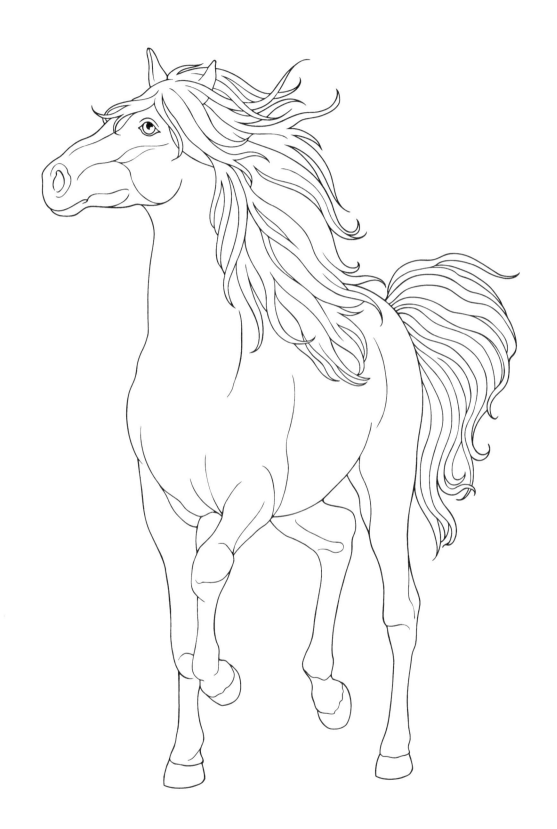

THOROUGHBRED

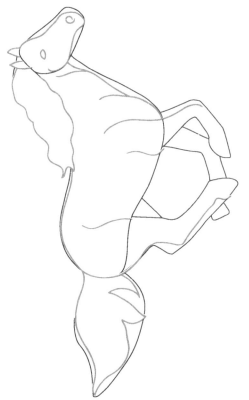

1. Draw an outline for the body and head. Add shapes for the mane and tail, and outline the legs.

3. Refine the head and jaw, and add some muscle lines to the horse's body. Refine the legs, and add wavy lines to the mane and tail.

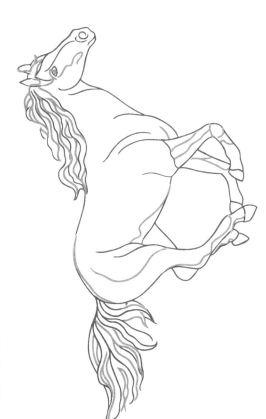

2. Define the shape of the mane and tail. Add the ears, and an outline for the eye and the nostril. Refine the shape of the head. Add lines to show where the legs extend into the body, and add detail to the back leg. Add some definition in the neck and chest.

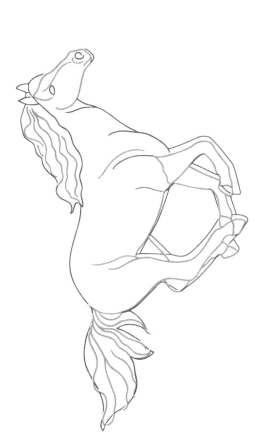

4. Add more lines to the mane and tail, and define the neck, legs, and ears. Enhance your drawing with additional detail as shown on the next page.

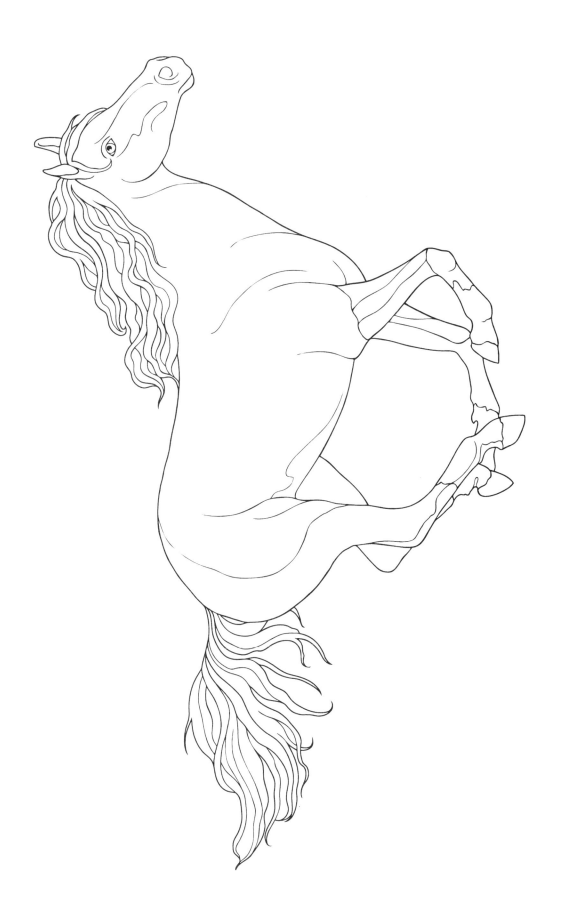

WELSH MOUNTAIN PONY

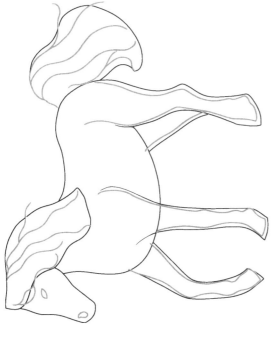

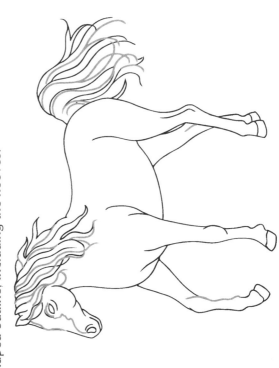

1. Draw shapes for the head and the mane. The shape of the body continues down into the back leg. Add a line suggesting the other back leg, and shapes for the front legs. Add a shape for the tail.

2. Add lines in the mane and tail, and add an outline for the eye and the nostril. Define the legs by creating a more accurately shaped outline, including the hooves.

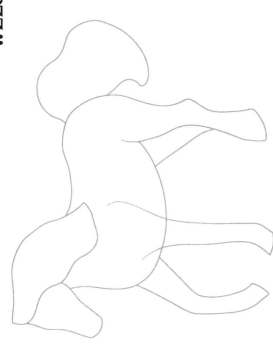

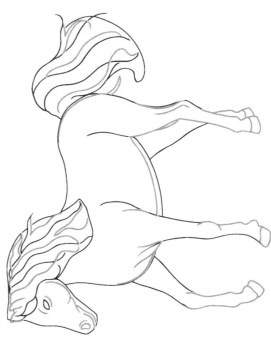

3. Add more line work around the nostril, mouth, and in the face. Notice that the horse's muzzle is narrower than the upper part of the face. Draw more lines in the mane and tail, add some hoof detail, and detail the legs and body.

4. Add more lines to the mane and tail, and add a blaze to the face. Add some detail to the legs. Enhance your drawing with additional detail as shown on the next page.

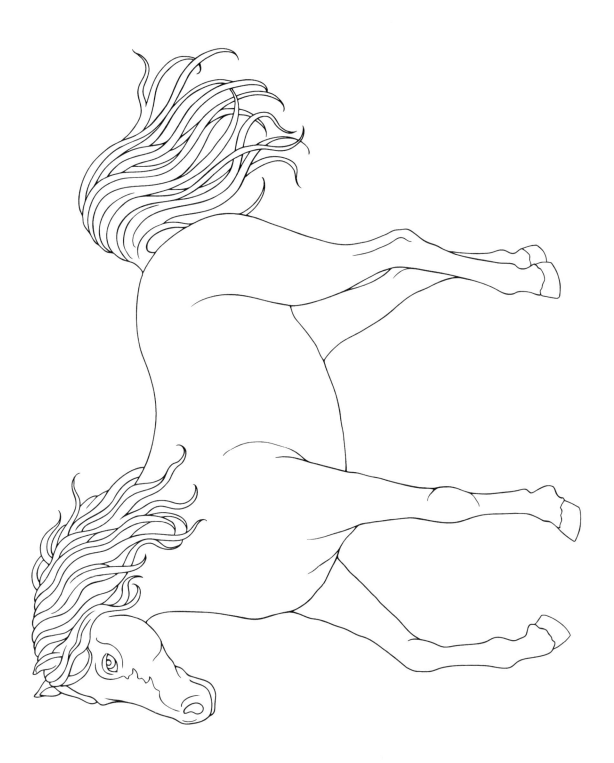